VISITING HOURS

'For those in peril'

The rights of Michel and Gillie Robic to be identified as the authors of this work has been asserted by them in accordance with the Copyright, Design and Patents Act 1988.

Typeset in Times New Roman

First Printing, 2025

Published by Clayhanger Press
www.clayhangerpress.co.uk

All rights reserved.

ISBN-13: 978-1-917017-07-7

VISITING HOURS

Doodles by Michel Robic

Words by Gillie Robic

Introduction

Michel's doodles have always delighted me, creating a world of strangely familiar creatures in a fantasy land of oceans and islands.

After a perilous stay in hospital the tone slightly changed. On the backs of envelopes (Michel never uses sketch pads) he summoned up the essence of what he experienced in his hospital bed. The black humour and affection for the monsters – both friendly and dangerous – allowed me to understand some of that experience.

The fragments of envelopes with their doodles increased. Inspired by the images I began to respond with poems, nonsense and otherwise. A storyline started to emerge until one day it seemed to me that here was a pamphlet. So thank you Roger Bloor and Clayhanger Press for publishing it and making these wonderful drawings available for others to enjoy.

Gillie Robic

The accuracy of a few material details notwithstanding, no actual events are depicted in these doodles, although some of them may have been prompted by hospital memories. The same applies to the nightmares and daydreams represented herein. The role of the unguided doodling hand in conjuring it all up is not to be underestimated.

No hospital equipment was damaged and no mammals, crocodiles, snakes, birds, arachnids, flying critters, sea monsters, spooks etc. were hurt in the making of these pictures.

Michel Robic

is the sun warming
is the sea green
is the ship coming
or fleeing the scene

down with the periscope
spy-eyeing him
the sun's not a source of hope
eating the rim

the little boats flounder
sea's choppy today
they'll never surrender
the dock of the bay

he sees the sun mouthing
he sits on the wall
and contemplates nothing
so nothing will fall

Ghosts are falling falling
head-first past wall-eyed bats
woken from inverted slumber
by the lumbering of diclofenacked vultures
bumping against him, picking at sutures
peering into his dilated eyes.

Even the spiders are reeling in the silk
for all the talk of bleeps and drips
alighting on his nose and slips
mumbling and stumbling from his mouth
gouts from his cannula,
granular amber catheter sighs.

He lies grinning as the paintwork peels
away everything that it reveals.

The air is thick with stars and random bleeps,
feathers and webs, assorted wings and teeth.
The i.v. ibis stands upright infusing,
Everyone applauds, everyone's enthusing,
though acoustic ghosts find the tech confusing.
The shark signals agreement, the owl continues musing.
The understated crocodile clacks his claws and smiles.
The Beek spins through space for a thousand thousand miles.

under the bed is a crocodile
with watchful eyes
and a hidden smile

he listens to beek's troubled dreams
in the bed above
or so it seems

he tries to interrupt beek's groans
with a gentle shove
as the mattress moans

the i.v. ibis pumps a dose
to make more blurred
what comes too close

the crocodile withdraws his snout
salutes the bird
over and out

the bed's become a skateboard attached to an infusion
the room is tilting sideways causing some confusion
the audience considers this is merely an illusion
but there are scales and teeth and monsters in profusion

whatever he's needing
he's in bed and bleeding
eyeballs and fangs
dinner-time pangs
it's feeding
time at the zoo

chomp chomp chump mgnah-mgnah slurp burp bleep drip
poot puddle glug blag blog brag maw more red head sore bed
wallow pillow fed swallow ping nosh pong pish hash gnash gnash
toes nose life farce glass smash ceiling feeling grist milling naked…
lunch crunch mmm

the gravity of the situation cannot be denied

it is indeed very grave

somebody's world stopped turning

everything fell

to earth

the centre of

gravity

turned everything

upside down

falling headfirst

into the grave

very grave

headstones unprepared

names un-graven

little grave ghosts gravely waiting

to help them

into the very grave

if a greater mass

does not pull them back

to safety

temporarily

there's a loverly sun out there.

there's a loverly moon out there

there's a bushel of fear in here

run fast as you can from here

maybe it's cold outside

maybe it's dark outside

maybe it's safe inside

maybe my life's inside

where can I find my tongue
where can I find my heart
's desire or even a chart
moth-eaten and singed and wrong

your tongue is still in your mouth
speaking with many more
your heart's a little bit south
but isn't the place that's sore

I'm listening to a bird
who might be a feather-brained fool
I'm listening to a bird
 a bird
 a bird

o ibis of my drugs and dreams and drool
pray tell me if you birds are here at all

I infuse
therefore I am

I weight
 until I am

I sing and sing
although I am

a still small voice

spider-wisps are angular
screentime is rectangular
weatherwatchers tangular
feathercatchers spangular
by further and by far
we must admit they are
but never by a country mile
can they outdo the crocodile

you're talking to a bird					absurd

I'm talking to a bird absurd

tunnel of love o tunnel of love
how you clank and clink loudly
o tunnel of love

your tunnel is glowing
your voice is the spheres
a cloud of unknowing
that holds all your fears
the crocodile's grinning
the friendly ghosts reel
the birds hope you're winning
and ask how you feel

the islands are hopping
from palm tree to tree
to dodge the bombs dropping
waves into the sea

the castles are sliding
back into the sand
and scarlet stars gliding
back into your hand

tunnel of love o tunnel of love
how you wave and wink proudly
o tunnel of love

with every bleep bubbles seep across
consciousness into a pink world
with a purple curtain opening wide
onto countryside green and flowing
glowing with health and a wealth of joy
where all the sleek furry creatures seek
to snuggle into your singing body

this is a dreamscape for escape when all these essential chemicals enter the stream
of consciousness with their shadows and shades of fear in every hue even the sky-blue
pink of dawn a threat greater than logic which departs flashing silver-
white across the synapses and the soles of the feet
tingle and burn and turn inwards flayed and laying the inside out
where lightning strikes iron in the blood and the flood of memories
dries around the edges and judgement sits on high handing down jelly-beans
to random private members and the calendar counts down september november
and skips over the shortest day the darknesses the depths moonless and sunless
dark star can't reflect on heavenly spinners
and spinnakers run before the wind which lifts the hair from your clammy neck
cool breezes fan the nape as you walk weightless
into the roaring shade

don't celebrate too fast
the sky may shred your parasol
don't lift your glass to toast
mere vapour from an aerosol
the crocodile is slow but fleet
be careful where you put your feet

Old Beek is out!

His mojo's back and so his breath
howls down the horn and mocks at death.
The jingle is his pointing hat's
that bells the rhythm to his cats,
who purr a syncopated purr –

O welcome home now, voyageur!

The Authors

Gillie Robic was born in India, her abiding passion, and lives in London with husband Michel. She attended the Sorbonne and l'UCAD in Paris, and the Central School of Art (Theatre Design) in London. She is poet, voice artist and puppet performer, designer and director in film, theatre and television.

She works with performance-based Impossible Poets, and is a founder member of Red Door Poets, who organise regular poetry readings and interviews.

Gillie is widely published in magazines and anthologies in the UK and the US. Her first collection, *Swimming Through Marble*, was shortlisted and published in 2016 by Live Canon, followed by *Lightfalls,* then *Open Skies* (a pamphlet in aid of Ukraine), and her latest collection, *I think I could be wrong,* with illustrations by Cristóbal Schmal and recordings of some of the poems.

Visiting Hours is her first collaboration with Michel, whose doodled creations have delighted her for years.

Michel Robic was one day old on 30th October 1943 in Cherbourg, occupied France, when an Allied air raid hit the hospital, killing some of the staff but missing the babies and the young mothers. This should have been a warning for him to stay away from hospitals, but he was too little to understand. A lifetime later, things have gone too far for avoidance to remain an option he could safely consider.

In the meantime, events of note have included his first work of fiction appearing in 1964 to some critical acclaim, his leaving France for misadventures in faraway places of which he knew absolutely nothing, meeting and marrying Gillie, settling in London, travelling to other faraway places, working in some of them, encountering the classical music of Northern India and writing in his kind of french language a few more books of modernist bent which have been published in France over the years.

An inveterate doodler since childhood, Michel Robic had never thought to offer any of his pictures for publication. All credit to Gillie for taking the initiative of this first collaboration.

www.ingramcontent.com/pod-product-compliance
Ingram Content Group UK Ltd.
Pitfield, Milton Keynes, MK11 3LW, UK
UKHW051119160125
453775UK00003B/18